The Reic

Ralf Wollheim

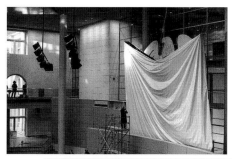

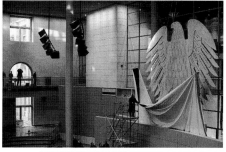

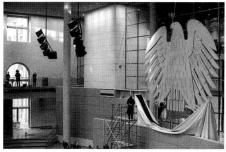

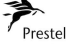

Prestel

Munich · London · New York

CONTENTS

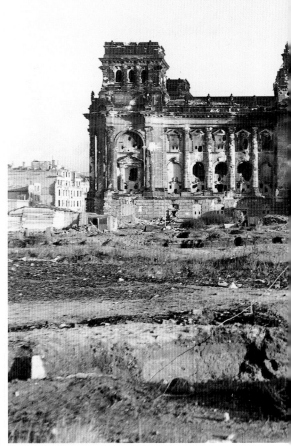

Above:
Aerial photo,
spring 1999

The devastated
Reichstag, 1945

INTRODUCTION

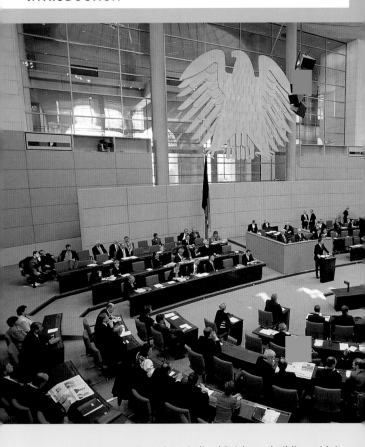

The first session in the revitalized Reichstag building, 1999

Norman Foster's revitalized Reichstag building with its glass dome has lost no time in becoming an emblem of the Federal German capital. Its popularity, attested to by the vast numbers of visitors who have thronged into it since its inauguration has made all discussions about how and whether to use the historic building and the long-lasting controversy about the dome recede into the background. The Reichstag building is not an isolated shell housing a political institution. It is a place at the heart of the city that people love to visit. More than six years of planning, construction work and preparations for moving from Bonn have left their mark on the heart of Berlin. Buildings and vast construction sites for the Bundestag

4

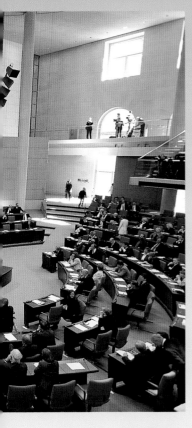

and the new Chancellery on the bend in the Spree as well as a host of ministries record Berlin's growth into the capital of a unified Federal Germany. The first Bundestag sessions in Berlin in 1999 mark a new era in the history of the Reichstag building, the paramount symbol of the political upheavals that have convulsed Germany in the past century.

History paintings depicting the German Kaiser Wilhelm II in the Chamber and photos of German soldiers organized in revolutionary councils and a poignantly historic one of Philipp Scheidemann standing in a window on the second floor of the Reichstag building to proclaim Germany a republic after World War I all document the change from imperial Germany to the democratic Weimar Republic. The rise and fall of Hitler's so-called Thousand-Year Reich are recorded in photos dating from the Reichstag fire in 1933 to devastated Berlin in 1945. These photographs are anything but textbook illustrations. They show the dramatic events in and around this building and have been deeply inscribed into the collective memory. They all pinpoint historic moments and they are memorable. The ruins of the Reichstag as a backdrop for post-war black-market dealings and the mass demonstrations held during the Berlin Blockade highlight the delayed consequences of National Socialism and the beginning of the early Cold War in Europe. Photographs of the Reichstag building reveal the political developments of past decades caught in a time warp. The sharp contrast

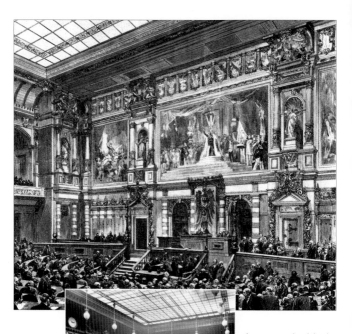

Left above:
The inauguration in the Chamber of deputies, 1894

Left bottom:
The Chamber of deputies, 1894

Right above:
The politician Philipp Scheidemann proclaims Germany a republic, 1918

Right bottom:
Soldiers' revolutionary councils, c. November-December 1918

between the bleak Reichstag building in the shadow of the Berlin Wall and the joyous crowds on 9 November 1989 is self-explanatory. This is where the decades-long partition of Germany was most evident. Germany's official reunification was celebrated on 3 October 1990–and most fittingly so–in front of the Reichstag building.

It is not just the somber witness of momentous political events. The presence of so many boys playing soccer on the lawn in front of the building attested to the fact that people had comfortably come to terms with life in West

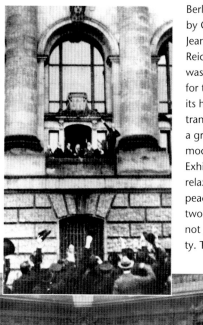

Berlin. Wrapped by Christo and Jeanne-Claude, the Reichstag building was a unique place for two weeks with its historic burden transmuted into a grandiose democratic art work. Exhilarating yet relaxed and always peaceful, those two weeks were not just a big party. They represent-

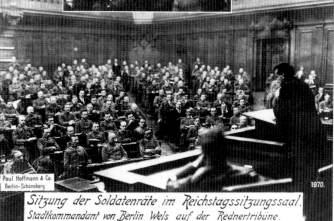

Paul Hoffmann & Co.
Berlin-Schöneberg

1970.

Sitzung der Soldatenräte im Reichstagssitzungssaal.
Stadtkommandant von Berlin Wels auf der Rednertribüne.

ed an uplifting communal experience shared by millions of people who cared about what was happening in Berlin. The debate about letting Christo and Jeanne-Claude go ahead with their project revolved primarily around what was seen by some as an insult to the historic dignity of the parliament building. When this political debate

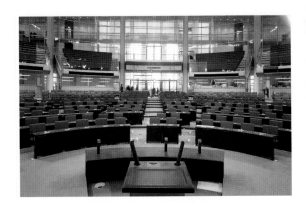

touched on the core issue of whether the Bundestag should be moved from the Rhine to the Spree, i.e. from Bonn to Berlin, the Reichstag building was still at the heart of the matter. Prussian dominance of German society, late 19th-century industrial arrogance and sabre-rattling, the failure of the short-lived Weimar Republic and its terrible consequences all added up to a volatile mix of reproach and prejudice against the Reichstag. For all that, German history ultimately tipped the scales in the building's favor. Since it was not weighed down with symbolic associations with National Socialism, using it to house a democratic legislature did not reinstate a link with Hitler's Third Reich.

Norman Foster's design, which he styles a "dialog between old and new", has kept the 1894 Paul Wallot facade and decoration. The basic structure has been retained whereas the Chamber and the glass dome are new. Most of the sculpture and the decoration on the facades were destroyed in World War II or in subsequent restoration work in the 1960s and 1970s. Norman Foster's interior utilizes the 19th-century arrangement of rooms. The old lobby and the smaller parliamentary rooms along the south and north sides are still in use. Today they are modern, with austerely elegant appointments and furnishings. The old imperial wall decorations made of stone and the built-in wooden features of the Wilhelminian era had been removed in the course of earlier renovations. Foster

Above: The Chamber in 1999, redesigned by Norman Foster

Right: The first Bundestag session after German reunification, October 1990

in contrast incorporated any historic fragments of decoration that came to light in his design. Traces left by history on the building such as countless graffiti scrawled by soldiers of the Red Army in 1945 were to be preserved as vital records of the past.

The function of the "dialog between old and new" is not to "clean up" or deny the Reichstag building's turbulent history. A modern Chamber has emerged from it, a deliberately bold venture in democratic politics and architecture. Glass partitions link the seat of parliamentary activity with the lobbies leading to it, thus ensuring the greatest possible transparency in all senses of the word within the building despite its massive outer walls. You can look down into the Chamber from the new dome, which is a milestone of contemporary architecture, a landmark of the vibrantly youthful Federal capital. The unexpected popularity of the reborn Reichstag building augurs well for the Bundestag in Berlin.

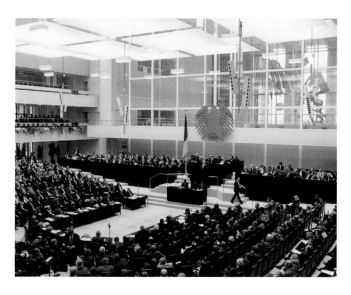

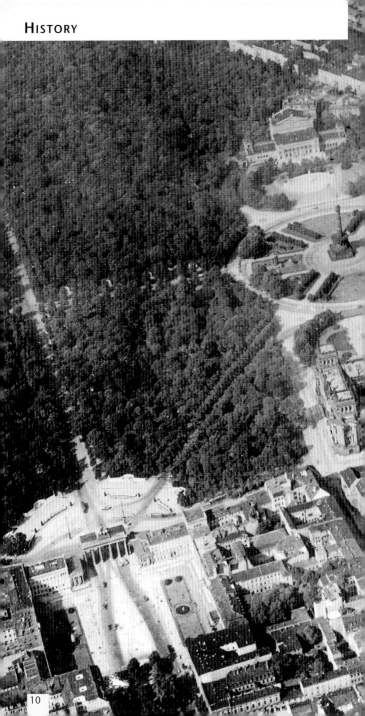

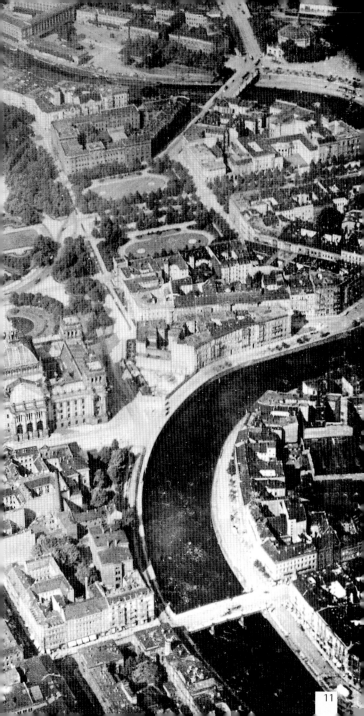

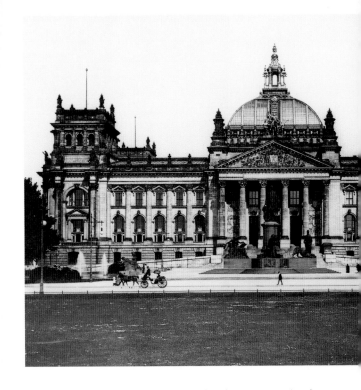

Page 10/11:
Aerial view of
the bend in
the Spree area,
c. 1930

Above: The
Reichstag
building, 1912

Right: The
Chamber of de-
puties in Leip-
ziger Straße,
c. 1880s

At the center of the bend in the Spree, Königsplatz was one of the most elegant addresses in 19th-century Berlin. The nobility and later the affluent upper-middle class lived on or near Königsplatz. Embassies were also located here. The General Staff building on the north side was a reminder that Königsplatz once had been an impressive parade ground. It was also a cultural center. Concerts were performed and balls were given in the splendid public rooms of the Kroll'sche Etablissement across from the Reichstag building from 1844. In 1898 it was converted into the "New Royal Opera House". The Victory Column stood at the center of Königsplatz until it was moved, with the Bismarck Monument, to the "Grand Star" in the Tiergarten park in 1938.

Built after plans by Paul Wallot, the Reichstag building was completed in 1894. It was weighted down by a

heavy dome set in four massive corner towers. The monumentality of the gloomy original was enhanced by the columnar articulation of its facade and a grand portico. The original building covered 137 x 97 meters and had two light wells. Its elongated facade on Königsplatz has two main storeys. Modeled on palatial architecture, the elevated second floor emphasized the importance of the centrally positioned Chamber. Here the large roundarch windows were interspersed with smaller decorative frames subdividing the facade into smaller units. Free-standing sculpture in front of the parapet around the roof articulated the facade in the vertical, relieving the heaviness of the broad front facade.

Four allegorical figures were erected on each of the four corner towers. The portico was crowned with a personification of Germania and the dome was surmounted by an "imperial crown". An imposing bevy of coats of arms represented the states under various

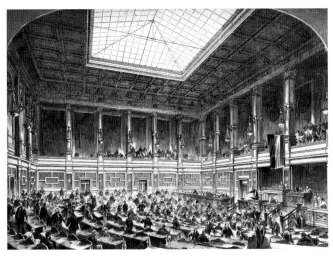

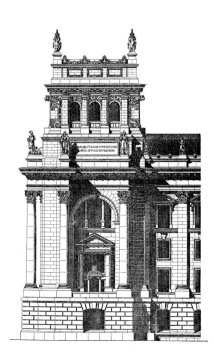

forms of government comprising the united German Empire. It took more than twenty years of planning before the Reichstag building was finally inaugurated in 1894. The German Empire, founded in 1871, needed a building to house the new parliament. An architectural competition was held as early as 1872. However, the winning design by Ludwig Bohnstedt was never built. It proved difficult to acquire a suitable site on Königsplatz. In addition, the building plans had to be reworked due to an altered planning scheme. Consequently, the imperial Reichstag continued to convene in temporary quarters made over to it by the Royal Porcelain Factory KPM at 4 Leipziger Strasse.

A second attempt at designing a Reichstag building was made in 1882. The competition fielded 189 participants and there was a tie for the first prize. Paul Wallot of Frankfurt and Friedrich Thiersch from Munich had to redraw their plans after the competition and Wallot won. Location on the bend of the Spree still had priority. This time the Reichstag succeeded in finally acquiring Count Raczynski's palace on Königsplatz and tore it down to make space for the projected Reichstag building. The site on the Spree with symmetrical grounds centering on the Victory Column might have been more appropriate for such a grand structure yet it no longer lay within the inner city. Instead it was cut off from it just as Wilhelm I had wished. Like his grandfather and successor on the German throne, Wilhelm II had no love for the Reichstag since it

Above:
The south-western corner tower, drawing by Paul Wallot

Right: The southeastern corner tower

14

symbolized the burgeoning of parliamentary government. Finally, after twelve years of aborted planning, two architecture competitions and continual reshaping of Wallot's plans, the cornerstone of the Reichstag building was laid

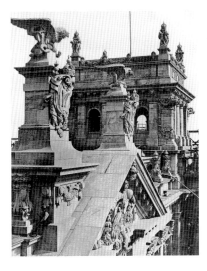

in 1884. The whole project was rehashed for years at all political levels. The floor plan, the position and form of the dome had never been settled and Wallot had to submit new plans from time to time during the painful gestation period. Construction work on the Reichstag building went on for ten years. An imposing structure with Renaissance and Baroque-inspired facades, it was sumptuously adorned with sculpture symboliz-

ing the states which had united to form the German Empire. The sculptural articulation of the facade shows up more clearly in the Wallot drawing than in contemporary photographs. Numerous committees of experts selected the sculpture and relief decoration, which included portraits of distinguished Germans and emblems from German history such as thinkers, princes and coats of arms, and decided how they were to be represented and positioned on the facades and inside the building. The Reichstag building committee was kept busy for years. Nevertheless, this showy political edifice, unlike Berlin Cathedral on Spree Island, was not typical of Wilhelminian historicizing architecture.

The extensive building with its horizontal facade articulation, columns and portico, is in some respects modeled on historical precedent. The original dome, by contrast, was innovative in the extreme. Glass construction of this type was then mainly used for exhibition pavilions and

railway stations. After all, Berlin Castle and Berlin Cathedral in the vicinity of the Reichstag building were crowned by conventional stone domes. Soaring nearly 50 meters above the building, the Reichstag's iron, copper and glass dome on its rectangular substructure became a milestone of modern engineering in architecture.

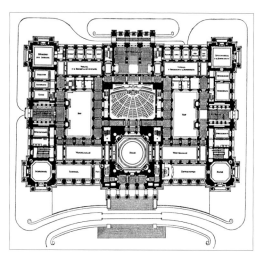

The ridges and ribs of the old dome supported a forceful silhouette. Copper-clad, the dome was gilded to make it stand out against the massive stone structures around it. It was literally crowned by its lantern, a stylized imperial crown high above the German parliament.

Because the Kaiser's wishes and those of the parliament's representatives clashed, debates on decoration were long drawn out. The finished building boasted allegorical representations of German imperial unity where they were most visible to the public: the huge imperial eagle on the pediments and a sculpture of Germania personified on the portico gable. The dedication "Dem deutschen Volke" (To the German people) was not put up in bronze letters above the entrance until 1916. As straightforward as these words might seem today, they had to be approved by the Emperor Wilhelm II, who was first cautiously approached about the dedication

Above: The ground plan by Paul Wallot

Right: The west facade, drawing by Paul Wallot, 1894

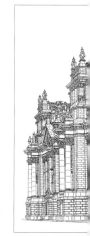

in 1895. His token acceptance of parliament as an institution came only two years before the German monarchy was abolished. The Kaiser presumably feared that he was unpopular and the throne shaky. Derogative terms like "Babblebox" and "Monkey House" he used when speaking of parliament reveal how Wilhelm II felt about it. Its inaugural sessions took place in the palace and not the Reichstag building.

The décor of the Reichstag building was clearly structured on hierarchical lines. The walls and floors of antechambers, stairwells and vestibules were left in natural stone to radiate "dignified solemnity". Offices and meeting rooms were made to look more "comfortable", with richly decorated ceilings and panelled walls. The most important rooms, including the chamber where the Bundesrat (the upper house) met, were sumptuously panelled and hung with paintings. Vast history paintings were commissioned for the Chamber of deputies, shown here on page 6.

On 9 November 1918 Philipp Scheidemann, a leading politician of the Social Democratic Party, proclaimed Germany a republic from a window of the Reichstag building. A revolutionary provisional government was formed and a general election was called for January 1919. Unrest in

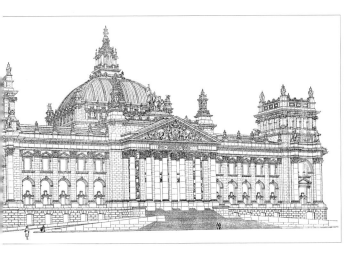

Berlin made the National Assembly withdraw to Weimar to draft a constitution. Parliament with Friedrich Ebert as Chancellor first sat in the Reichstag building again in August. During the ill-fated Weimar Republic the scene of stormy political debate, the Chamber was redesigned to accommodate an increase in the number of members caused by the introduction of proportional representation.

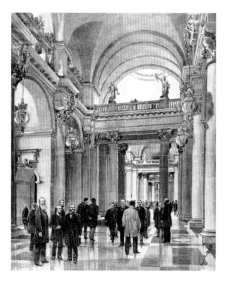

By the 1920s Germany had left imperial pomp and circumstance far behind. Ludwig Hoffmann, the Berlin municipal architect, noted in his diary while he was serving on a committee for decorating the Reichstag building in 1922 that what was really needed was a committee for ridding the building of its decoration. And Ludwig Hoffmann derided it by calling it "a luxury hearse".

During the 1920s the Wilhelminian Reichstag building was by and large left as it was. Plans for a separate building to rehouse the parliamentary library, which had grown too comprehensive for the rooms in which it was kept, led to an architectural competition in 1927 but the deepening worldwide economic crisis and the accompanying galloping inflation deprived the Weimar Republic of the means for funding construction work.

Königsplatz (King's Square) was renamed Platz der Republik (Republic Square) in 1926, a defiantly political gesture that was reversed by the National Socialists after they swept to power.

Even before Hitler became Chancellor, on 30 January 1933, the Weimar Republic had been governed by emer-

Above:
The vestibule

Right:
The Reichstag
building, 1921

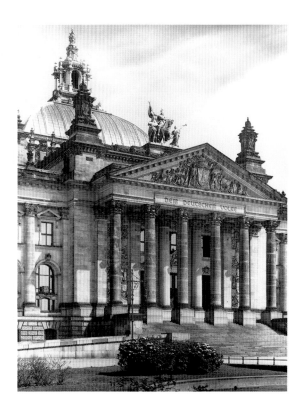

gency decree after neutralization of the Reichstag as early as 1930. Parliamentary government was then virtually eliminated by Hitler's totalitarian Enabling Act of 24 March 1933. After this act was passed, the Reichstag only convened 19 times in the years to come.

The National Socialist Enabling Bill became law in the Kroll Opera House occupied by the Reichstag after the Chamber had been gutted and the dome damaged by fire on 27 February 1933. A Dutchman, Marinus van der Lubbe, was arrested the evening of the fire, charged with arson and later on executed. At the same time Communist members of the Reichstag were imprisoned and all Communist and Social Democratic party publications were prohibited. From 1 March 1933 the "Law for Removing the Distress of People and Reich" suspended fun-

damental civil rights and crippled political opposition. These ominous events following closely on the Reichstag fire are what lent heavy symbolic significance to the building sustaining such severe damage.

The gutted Chamber was cleared out after the Reichstag fire and the damaged dome was repaired.

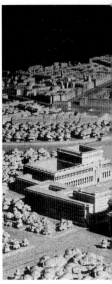

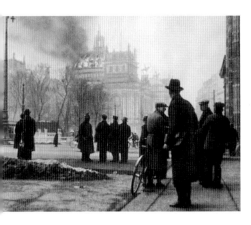

Undamaged tracts of the Reichstag building continued in use. The library, officially renamed "Central Political Library of the German Reich", remained in the building until 1939. Propaganda exhibitions addressing the public at large entitled "Bolshevism Unmasked" (in winter 1937) or "Always the Jew" (in 1939) unmistakably indicated where National Socialism's propaganda and politics were going.

Above: The Reichstag fire on 27 Februar 1933

Right above: The "Hall", with the Reichstag on the right, 1939, model by Albert Speer

Right: Raising the red flag, May 1945

The National Socialists made comprehensive plans for redesigning the entire area around the bend in the Spree rather than just the Reichstag building itself.

Albert Speer, Hitler's pet architect, projected a North-South axis bisecting Berlin and ending here in what was to be a huge "Hall". Planned as the world's largest building, the Hall would have made the Reichstag building look like a gazebo on the square in front of it. Meant to house only a library, archives and a restaurant, the Hall was never built but structures near the site were demol-

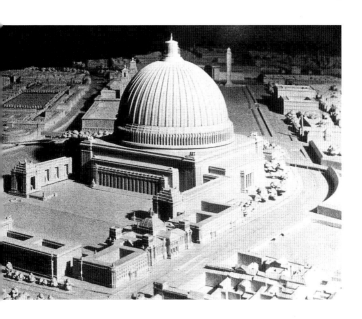

ished to make way for it. The beginning of World War II put a stop to these gigantesque plans.

Bombing raids did little damage to the Reichstag building. However, by May 1945, fighting in the heart of Berlin was raging around it. The Red Army attached great symbolic significance to this particular building and taking it was of paramount political importance. As a final act of conquest photographs were staged of victorious Russian soldiers recording the storming of the building and the raising of the Red flag on its roof. After Germany surrendered, Soviet soldiers

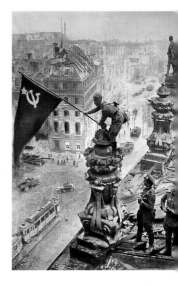

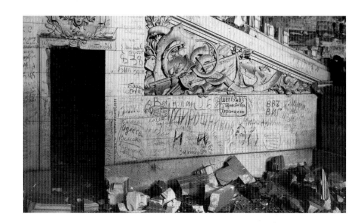

left their mark for posterity on the ruined building. Glad to have survived and won the war, most of them merely scrawled their names, home towns and rank on its walls.

The photos of the ruined Reichstag building soon came to symbolize the destruction and squalor of conquered Berlin around the world. After 1945 the square in front of it grew into a major black market locale. The trees in the Tiergarten park were felled for firewood and the park became a vast field on which the people of Berlin grew vegetables.

Even more haunting in some ways than the photos of destruction were pictures of demonstrations during the

Above: Russian graffiti recall the capture of Berlin by the Red Army, summer 1945

Left and right: People clearing rubble, c. 1946

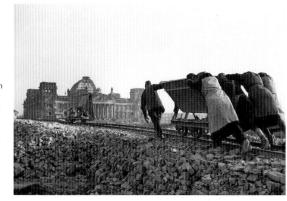

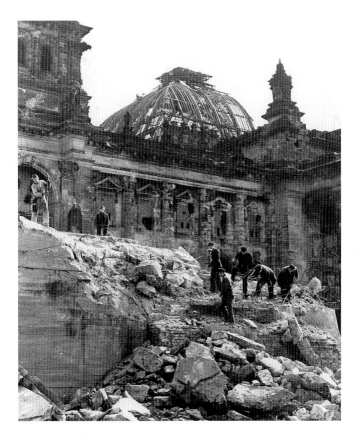

Berlin blockade. In 1948 Ernst Reuter gave his famous speeches against the backdrop of the ruined Reichstag building and mass demonstrations were later held there annually on 1 May.

For a long time the fate of the Reichstag building was uncertain as Berlin was partitioned into four occupied sectors and the cold war deepened. In 1950 clearing up the rubble inside it began while debate raged on whether to rebuild or demolish it. Four years later the damaged dome was blown up and the Bonn government was still discussing uses for the building. In 1955 the Bundestag voted to rebuild it. The newly established Federal building authority carried out some of the projected steps. In a

deliberate repudiation of Wilhelminian historicism, much of the sculptural decoration of the facades was removed. The building was stripped of arch crowns, bosses and interior windows on the first floor and all coats of arms. The architect Paul Baumgarten won a competition for redesigning the building on a modest scale and in 1961 his plans were made the basis for further reconstruction. However, the occupation of

Berlin by the Four Powers and the building of the Wall on 13 August 1961 put paid to ideas of housing the Bundestag in the Reichstag building.

By 1970 renovation of the Reichstag building was over yet there were still no concrete plans for using it. After all, the stopgap building was now in Berlin and not in Bonn. The Chamber was only used occasionally for committee or party meetings or large conferences. From 1971 the Reichstag building was mainly used to house an exhibition entitled "Questions Put to German History". Steeped as it was in German history, the building was the ideal place to mount an exhibition commemorating the founding of the Reichstag 100 years before.

Above: The Chamber, 1967

Right: Rebuilding the Reichstag, 1958

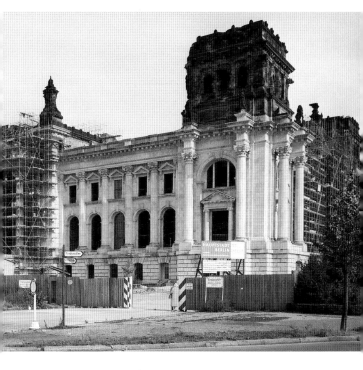

Baumgarten's design for the Reichstag building revealed a decided distaste for the 19th-century period of German imperial historicism, a feeling shared in those years not only by architects. Affording an unobstructed view from the western entrance into the Chamber, the large west lobby was by now devoid of decoration.

The 1961 restoration kept Wallot's original lofty ceilings and room proportions as they were. However, the overall effect was now intended to be one of simplicity but in fact bordered on harsh austerity. Transparency and spaciousness were the aims and they were best achieved in the west lobby. A vast hanging sculpture by the artist Bernhard Heiliger was suspended in it.

Viewed from the outside, the Reichstag building now seemed clumsily proportioned. Without its dome, with its corner towers reduced in height and its facade stripped of most decoration and soon defaced to its original gray,

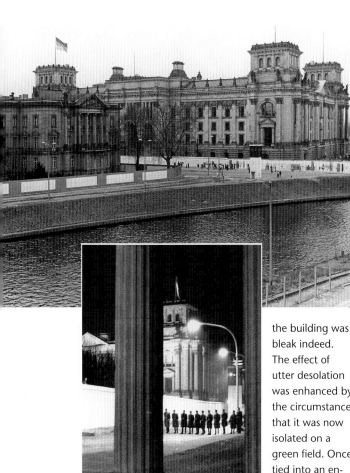

Above:
The Reichstag building and the Berlin Wall, 1989

Left:
9 November 1989: Looking from the Brandenburg Gate toward the Reichstag

Right: The Wall, November 1989

the building was bleak indeed. The effect of utter desolation was enhanced by the circumstance that it was now isolated on a green field. Once tied into an ensemble of buildings on the square, the postwar Reichstag was left alone on the outskirts of the devastated Tiergarten park. Cut off from its original urban context by the Berlin Wall, it now represented the outer fringe of West Berlin. The section of the Wall just a few meters behind it ran around the Brandenburg Gate, now in East Berlin, and continued on to the Spree.

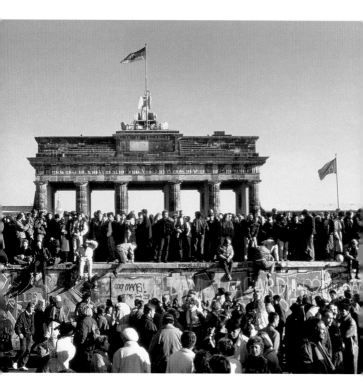

The Brandenburg Gate has come to signify German reunification because this is where East and West Germany had been symbolically severed. The Reichstag building did not attract public attention until long after 9 November 1989, the day the Berlin Wall came down. On 3 October 1990 reunification was celebrated in front of it and the united Federal German Bundestag convened for the first time in the Chamber. Not until the summer following Roman Herzog's election as President in 1994 was the Reichstag building catapulted into the limelight by a unique event preceding construction work: Christo's and Jeanne-Claude's wrapping of the entire building (see page 62/63).

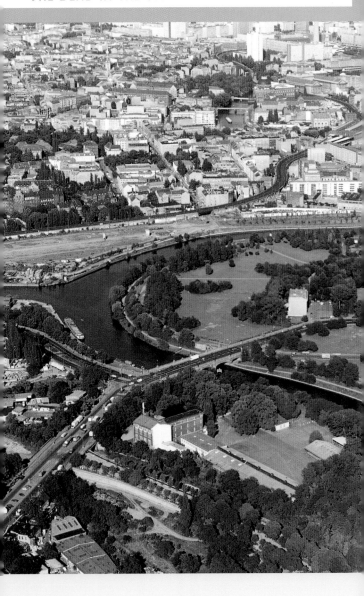

The historic city center and the bend in the Spree, 1993

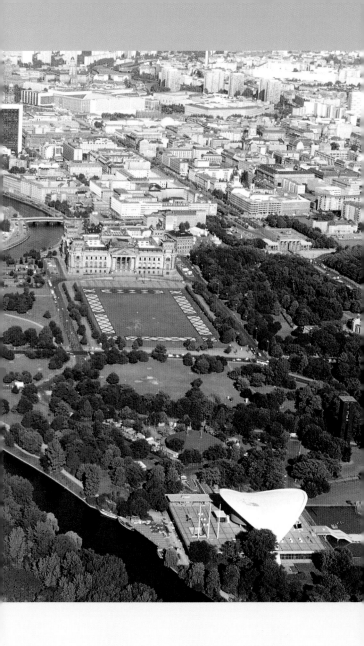

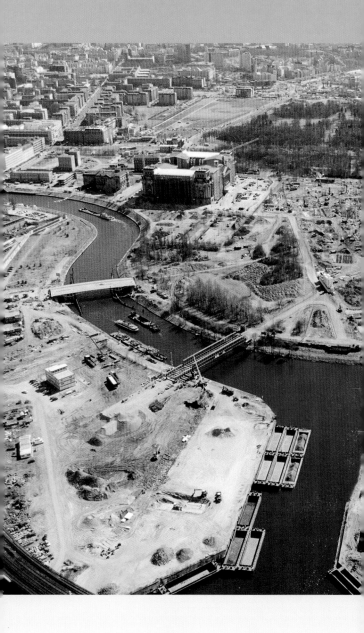

The bend in the
Spree after work
started, 1996

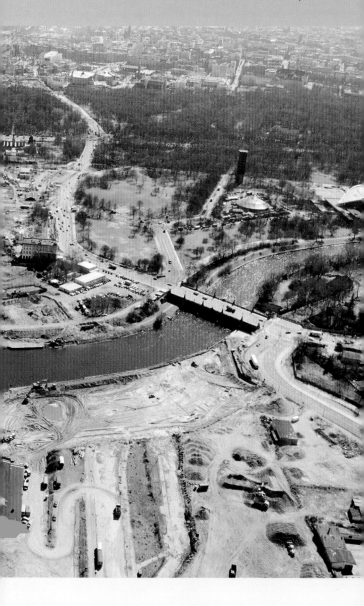

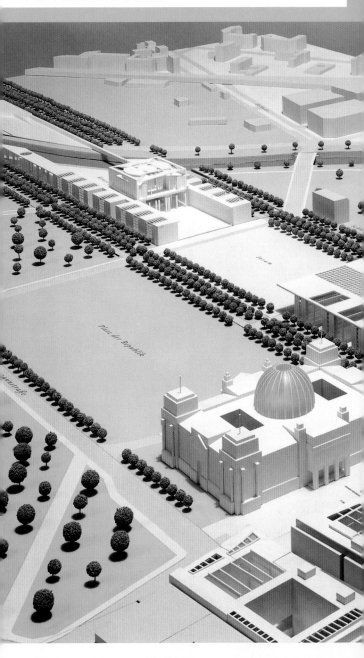

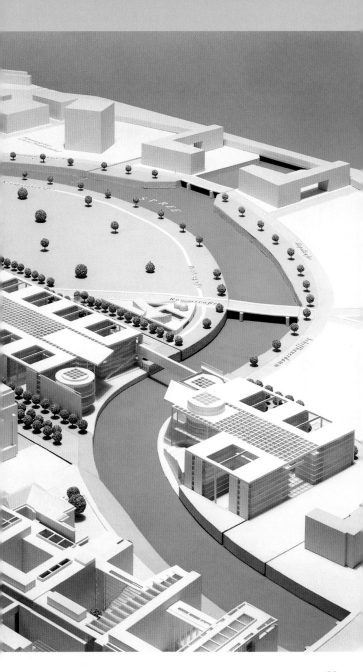

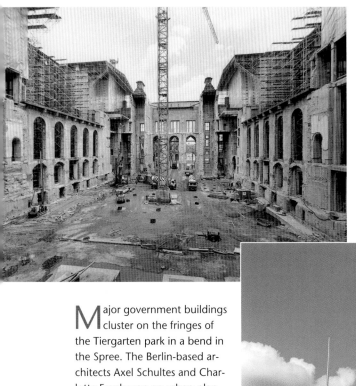

Major government buildings cluster on the fringes of the Tiergarten park in a bend in the Spree. The Berlin-based architects Axel Schultes and Charlotte Frank won an urban-planning competition in 1993 with a masterplan for the "government precincts" ("Band des Bundes"). It calls for an axis joining east and west formed by buildings stretching one and a half kilometers. The new Chancellery is being built to the west of the Reichstag building (page 32/33). The Paul Löbe House next to the Reichstag building is aligned with it. It houses parliamentarians' offices as well as administration and committee rooms. The east-west axis continues across

Page 32/33:
The masterplan for the bend in the Spree

Above: Gutting for reconstruction, the construction site in 1996

Right: The redesigned Reichstag building, 1999

34

the Spree with the Marie Elisabeth Lüders House, which accommodates offices and the Bundestag library. To the east of the Reichstag building, the Jakob Kaiser House has rooms for the political parties, individual parliamentarians and government offices. The "government precincts" continue on west across the Spree with the new Chancellery Park.

An international architectural competition was held in 1993 for redesigning the Reichstag building. The well known architects Pi de Bruijn (The Netherlands), Santiago Calatrava (Spain) and Norman Foster (Britain) were awarded first prizes from a field of 80 contestants. After a reconsideration phase which included considerable modification of their compeition-winning plans, Foster and

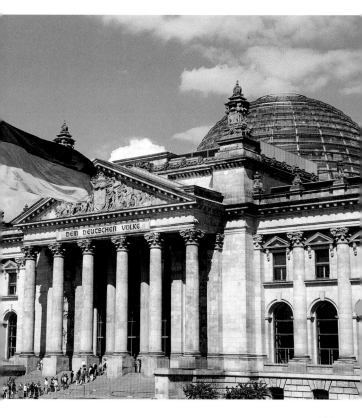

DEM DEUTSCHEN VOLKE

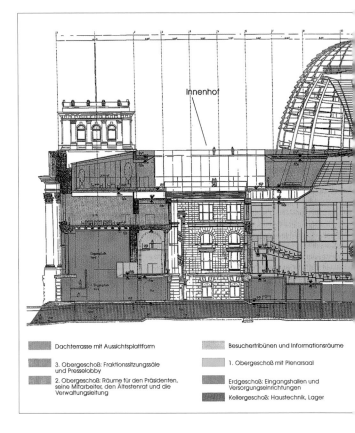

Innenhof

Dachterrasse mit Aussichtsplattform	Besuchertribünen und Informationsräume
3. Obergeschoß: Fraktionssitzungssäle und Presselobby	1. Obergeschoß mit Plenarsaal
2. Obergeschoß: Räume für den Präsidenten, seine Mitarbeiter, den Ältestenrat und die Verwaltungsleitung	Erdgeschoß: Eingangshallen und Versorgungseinrichtungen
	Kellergeschoß: Haustechnik, Lager

Partners were awarded the final contract. Their original design had called for a huge glass canopy above the old Reichstag building. After a spate of changes in overall design and a lot of discussion on if and how to rebuild the dome, plans were finally agreed on for the stunning walk-in dome. A felicitous choice, it has proved a smash hit. The Reichstag reconstruction and revitalization took four years and cost 600 million DM. 45,000 tons of rubble were excavated and moved from the construction site and 20,000 cubic meters of concrete were used for construction inside the gutted shell.

Foster's design unites respect for the extant historic building and modern solutions for meeting the needs of

The Reichstag building in section

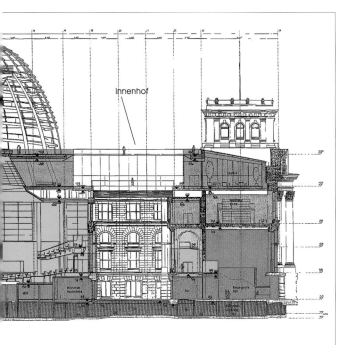

Innenhof

late 20th-century parliamentary activity. Moreover, the Foster design is at the cutting edge of ecological technology. A power plant generating both energy and heat driven by environmentally benign biofuels, solar collectors, natural lighting and ventilation as well as an aquifer and a subterranean lake acting as a thermal fly-wheel to store and recycle heat and cold, function unseen.

The section drawing shows the Reichstag building on a level with its side entrances. The ground floor is used for supply and storage purposes. The section indicates that the Chamber reaches to the top floor. Guests of the Bundestag are accommodated in the visitors' gallery and other rooms on the new mezannine above the Chamber.

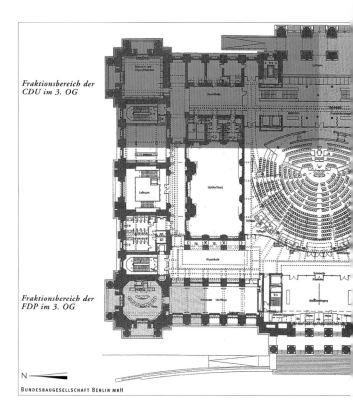

Fraktionsbereich der CDU im 3. OG

Fraktionsbereich der FDP im 3. OG

N

BUNDESBAUGESELLSCHAFT BERLIN MBH

The third floor has more official reception rooms and is subdivided as it was originally in 1894. Above it a new storey has been added, as you can see from the top-lighting and the modern facades facing the light wells. The section plan also demonstrates the dual function of the inverted glass conical element: from the dome it suffuses the Chamber with diffused light and from low down it ventilates the room itself as a convection chimney sucking out hot air.

The central location of the Chamber, which is demarcated by the lower rim of the dome, is clearly recognizable from the ground plan of the main floor. The principle entrance used by members of the Bundestag and staffers is on the east side. The narrow sides have additional entrances. The public enters the building through a large

Ground plan of the Chamber storey

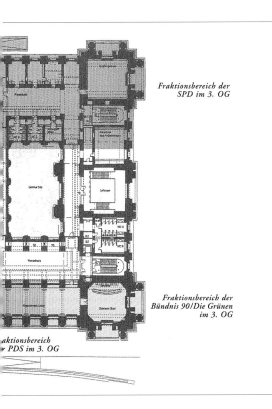

Fraktionsbereich der
SPD im 3. OG

Fraktionsbereich der
Bündnis 90/Die Grünen
im 3. OG

aktionsbereich
PDS im 3. OG

columned portal on the west side. The central space containing the Chamber, with seats for the members of Deutscher Bundestag in a roughly ellipsoid arrangement, was completely redesigned by Norman Foster whereas the division into rooms of the north and south wings has been left as it was, as the thick walls show (see diagram).

The main lobby, the foyer and the parliamentarians' restaurant on the west side have retained the dimensions and position they had in the old building. The passages around the two light wells, also a decisive feature of the original building, provide a welcome guideline in this vast structure. The rooms used by the various parties are marked in color on the plan. This is a diagram of the fourth floor, where the individual parties can meet in separate rooms.

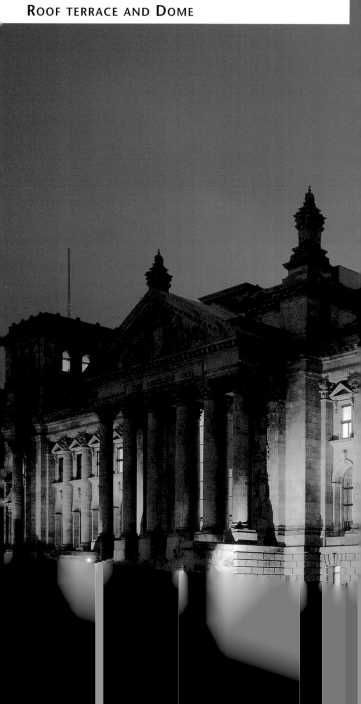

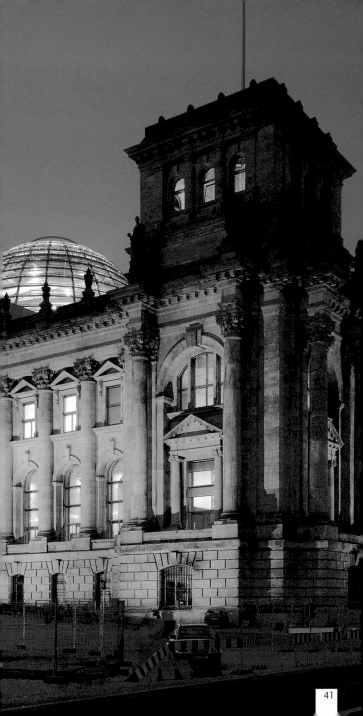

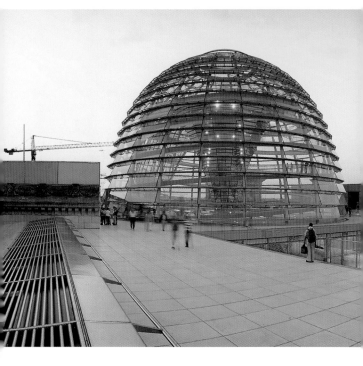

Page 40/41:
The Reichstag
building at
night, summer
1999

Above:
The public
roof terrace

Right: The
west lobby

Its dome visible from afar, the new Reichstag building has become the emblem of the new German seat of government. Stunningly lit up at night to show off its airy construction, the new dome has lent what was once a stolidly massive building transparency and spaciousness.

The reconstruction is the work of the English architectural firm of Foster and Partners, world famous for their passionate commitment to remaining at the cutting edge of contemporary architecture. The Foster and Partners' "architectural trademark" is striking steel and glass construction. Not just a catchphrase, high-tech architecture in the hands of Foster and Partners means high-powered engineering using technology that is both state-of-the-art and friendly to the environment.

Norman Foster founded his own firm of architects in 1967. It was soon at the forefront of British architecture. A well known Foster building in Germany is the Com-

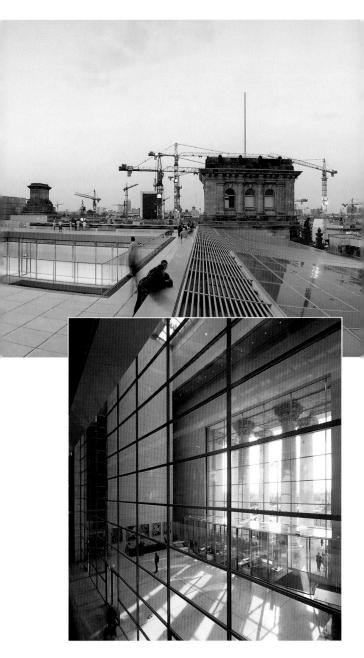

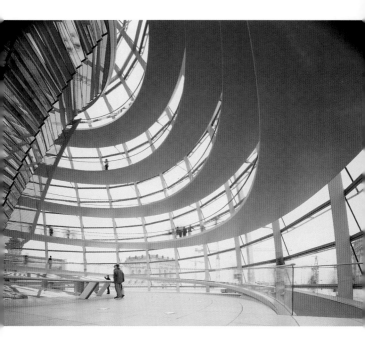

merzbank skyscraper in Frankfurt. Other projects of this international architectural office have included several conversion buildings in Germany and abroad as well as projects on a grand scale like the headquarters of the Hongkong and Shanghai Banking Corporation in Hong Kong, Stansted Airport near London and the new international Hong Kong airport on an artificial island.

Foster's experiences of enhancing historic buildings go back to the Carré d'Art, a museum in Nîmes in France, and the Sackler Wing of the London Royal Academy.

Knighted in 1990, he was awarded the coveted Pritzker Prize, generally regarded as the "Nobel Prize for Architecture", in 1999 as well as in the same year the Bundesverdienstkreuz, one of the highest honors Germany has to give to an individual person, in special regard of his successful revitalization of the new seat of parliament in Berlin.

Given a total facelift, the Reichstag building has lost its menacing look. Its sandstone facades have been cleaned

Above:
Inside the dome

Right: The
structure
of the dome

to reveal their original tawny hue. Nevertheless, the traces left by history on the building's flanks are still legible. Light-colored patches mark the scars made by artillery fire and hand grenades during the days of the Battle of Berlin in April and May 1945 when Soviet soldiers strove to take the Reichstag building, a strong symbol of Nazi imperialism for them.

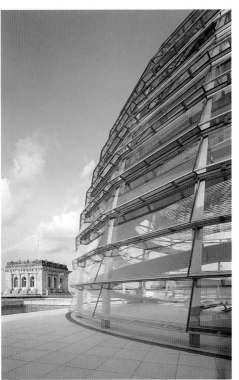

Visitors enter the Reichstag building through the west entrance facing the Tiergarten park. Thirty meters high, the spectacular lobby has a glass porch that also serves as a security check. The glass-walled west lobby gives on to the Tiergarten park, the Congress Hall and the new Chancellery and, on the other side, affords an intimate glimpse into its immediate surroundings and the Chamber, where the Bundestag (the lower house of parliament) convenes. Glass lifts spirit visitors from the ground-floor lobby up to the public roof terrace.

Norman Foster's rooftop terrace is a very special place indeed right in the center of Berlin. An oasis of tranquillity far above the pulsing metropolis, it affords a spectacular view of the city in all directions. Furthermore, it boasts a restaurant seating 100 visitors and a terrace of its own

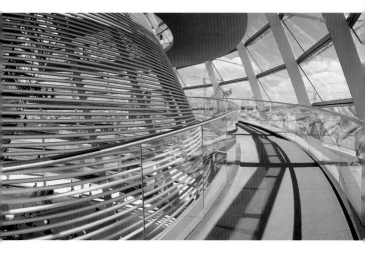

with room for 100 more. It faces east to the old Friedrich Strasse Station, to the Spree and the Television Tower on Alexander Platz.

Nestled between the four original Reichstag corner towers and the new glass dome, the light-colored, stone-paved terrace puts visitors at eye-level with the towers' well-preserved vase sculpture, a deliberately modern gesture in a historic context. The partitions around the two light wells are of glass so they do not obstruct the visitors' view.

From the roof terrace you have a grandiose panoramic view out across the roofs of the city, whose face is changing almost every day as vast construction sites mushroom and gradually vanish only to yield to new ones. Close by, Pariser Platz with its modernist structures by architects like Frank O. Gehry or Christian de Portzamparc, the Brandenburg Gate and Unter den Linden boulevard form the eastern boundary of the historic city center.

Above: The way up to the public viewing platform

Right: The Chamber lighting system

Visitors can walk into and around inside the new glass dome. Only vaguely reminiscent of the dome once atop the stone Reichstag, its main purposes are to shed light on the inner workings of parliamentary democracy in the Chamber below and to let visitors in on what is going on there while they are taking in the breathtaking view

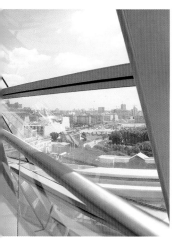

across the city. The dome makes the Reichstag building 47 meters high. Visible from a great distance, the dome disappears when you are close up to it. Built in 1894, the old Reichstag building was 75 meters tall with its dome, rivalling the castle dome on the Spree island (the castle was blown up in 1950), to figure much more prominently in the cityscape.

The modern dome, however, is magical when lit up to glow in the Berlin night sky.

The new dome atop the Reichstag building is 40 meters in diameter and 23.5 meters high. It is open at the top to ventilate the Chamber where the lower house of the Federal parliament convenes. Weighing 800 tons, the dome's steel skeleton comprises 24 arched steel ribs supporting 17 equidistant horizontal rings and is triangular in section, tapering to the top. Glass plates, each of them nearly five meters square, clad the steel skeleton like scales. Narrow glass bands border the structure externally in the horizontal. Only the four bottom rows have been left open to facilitate ventilation in the Chamber.

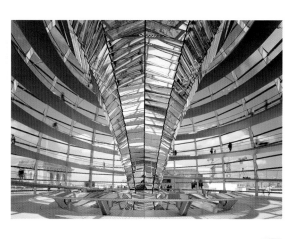

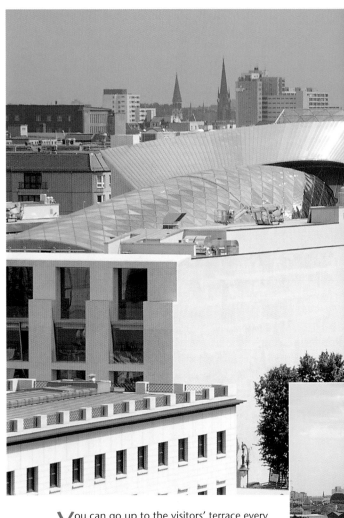

Above: The view on Pariser Platz with Brandenburg Gate and Frank O. Gehry's building for the DG Bank

Right: The view to the east

You can go up to the visitors' terrace every day without making any prior arrangements to do so. The view across the city is breathtaking. The skyline forms a dramatic backdrop for a plethora of buildings. Close by, Pariser Platz, the Brandenburg Gate and Unter den Linden boulevard form the eastern boundary of the historic city center.

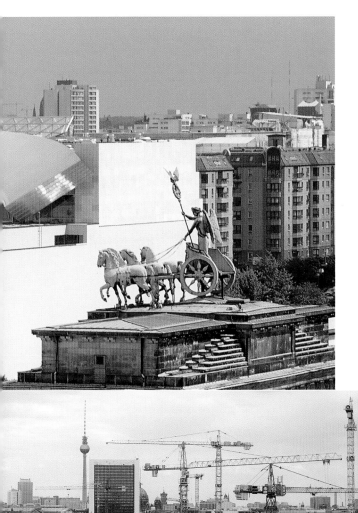

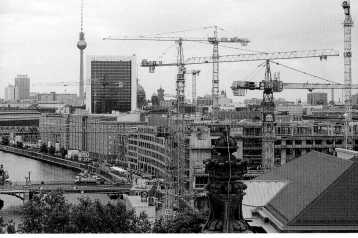

49

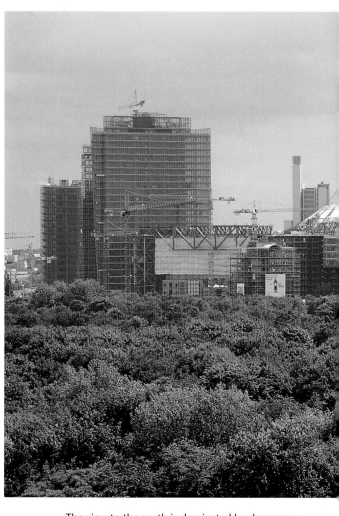

The view to the south is dominated by skyscrapers thronging re-emergent Potsdamer Platz. The Culture Forum abuts it to the west, as does the Tiergarten park. Up here you can survey the government precincts (Band des Bundes), which comprise the Paul Löbe House north of the Reichstag building, housing parliamentarians' offices, and the Chancellery. Together they bisect a broad green belt which borders the Spree.

Above: The view on Potsdamer Platz

Right: The view on the Chancellery

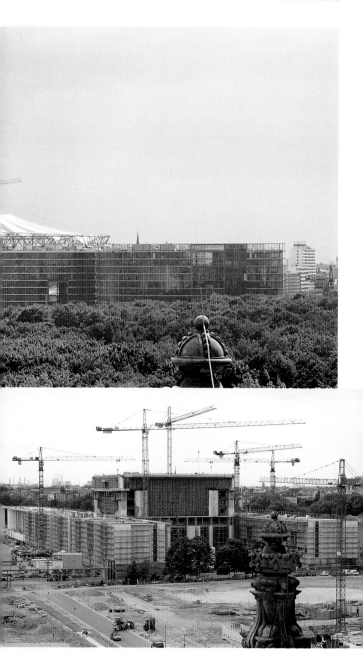

Norman Foster has turned the Reichstag Chamber around to face east again. The 1960s restoration left parliament facing the western entrance. Now the members of the Bundestag once again look at the speaker's lectern, the front benches and the Government in the east as they did a century ago.

However, 19th-century pomp has yielded to an astringently elegant décor. Neutral gray is the keynote with blue covered chairs adding a touch of color. Foster's idea is that the Reichstag building lives from what is going on inside it and is, therefore, merely a reticent setting for political activity. The dimensions of the Chamber have been considerably altered. With a 24-meter ceiling, it is now full four floors high.

A spacious room, it boasts a floor area of 1200 square meters and (currently) seats for 669 members of the Bundestag. The roughly ellipsoid arrangement of the members' seats is underscored by twelve supporting béton brut pillars ordered in a circle, with the speaker's lectern at the center and the front benches as the focal point of the Chamber. Floor to ceiling glass partitions on the east and west sides as well as the attenuated slenderness of the pillars enhance the effect of spaciousness and transparency created by this vast room. Although the seats are not far apart from each other, the sheer size of the Chamber counteracts closeness and intimacy.

On the west side of the Chamber, sloping tribunes that seem to float are boldly cantilevered out above the parliamentarians' heads. The tribunes seat 400 guests,

The Chamber, view from the east

52

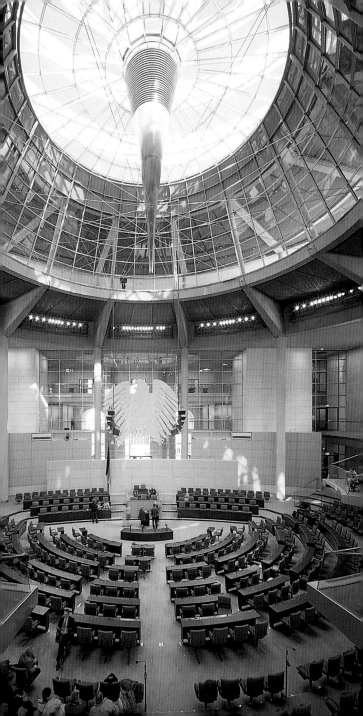

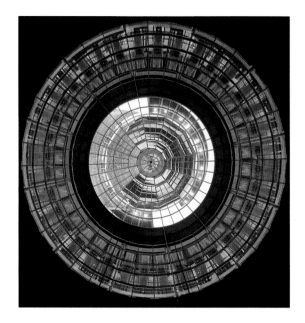

representatives of the media and the protocol. The glass gallery balustrades with steel handrails are a handsomely functional element that recurs throughout the building: in the stairwells and up the interlocking helical ramps in the dome. Not as far above the floor of the Chamber as they look, the tribunes afford an intimate glimpse of what is going on there. Beneath them are interpreters' cubicles and permanent positions for television cameras.

The dome is not the only source of daylight in the Chamber. Foster's reconstruction has extended the room as far as the flanking light wells to increase the input of natural light. The light well walls reveal how radically the old building has been gutted. Now the Chamber fills the central tract of the building. Round-arch windows are the distinguishing feature of the old main floor. The square windows above them originally articulated the third floor. All that is left of the middle section of the historic building is a shell enclosing modern spaces.

Above: The cone viewed from below

Right: The press foyer

The eagle goes back to the original emblem designed by the sculptor Ludwig Gies in 1953 for the Bonn Bundestag. The new eagle, specially made for the Berlin Chamber, is roughly a third again as large as the old one, which was fondly dubbed "the fat hen". Made of aluminum plates, the sleeker-looking Berlin variant weighs 2.5 tons. Since the emblem was never hung free in space, Norman Foster has designed a reverse for the new model, slightly varying the Gies design.

Foster's masterplan for the Chamber places the emphasis on the new elements introduced into an old setting. The old side walls are faced in the original stone but the pillars, the new ceiling and parts of the loadbearing structure are of béton brut.

Just where you might expect a chandelier, an silvery cone pierces the central opening in the ceiling.

Glittering like an icicle, the projecting cone is the end of the mirrored inverted cone inside the dome. Not merely a source of diffused daylight, the cone is also a sophis-

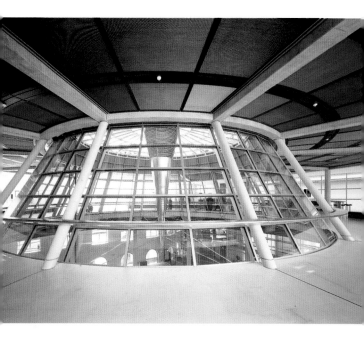

ticated convection chimney for ventilation, fitted with horizontal louvres where it meets the ceiling. They suck up stale air from the Chamber and discharge it through a vent on the observation platfrom. Fresh air enters the Chamber via ducts concealed in the floor of the room and the tribunes. Viewed from below, the vast dome is an abstract pattern, a compelling geometry of segmented concentric circles. Horizontal steel bracing stays converge on the cone to form a delicate asterisk. The curved glass walls of the press foyer stand on an enormous ring supported by cantilevered arms. Seen from directly below, the inverted cone, which is clad with adjustable mirrors to reflect daylight into the Chamber below, is flattened but noticeably lighter than the glass around it.

The press foyer is on the fourth floor of the building. From it journalists can lean comfortably on a sloping glass balustrade encircling the cone to observe the workings of the Bundestag down below. The meeting rooms for the political parties are arranged around the press foyer and

Above: Large party meeting room

Right: The south light well

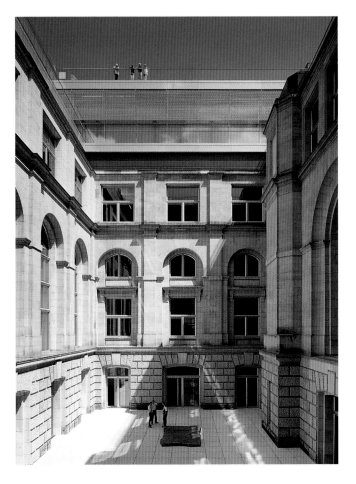

the light wells. Glass-walled on three sides, the press foyer looks into the west lobby and both light wells. Floor to ceiling windows give it a spacious feeling. Furnished only with four long, curving benches and a cafeteria counter, the room is entirely focused on the glass element at the center. Although the paths of visitors and parliamentarians rarely cross in the Reichstag building, the press and politicians are meant to be on an intimate footing here. When regular Bundestag sessions begin in September 1999, the Reichstag building will come to life. On the

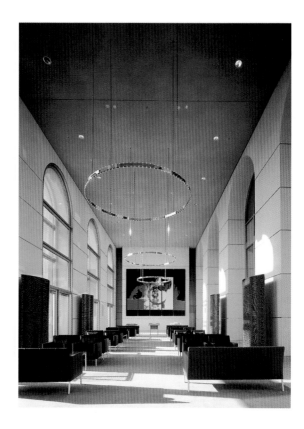

photographs it is in a state of suspension. After the parties have moved into their quarters, this building will soon hum with political activity as the hub of the capital.

The rooms for the political parties are hidden behind the attic, a 19th-century decorative feature above the fourth cornice. Flanking the main entrance of the building are large meeting rooms for the SPD (Social Democratic) and CDU/CSU (Christian Democrat/Christian Social Union) parties. Of the same size, the two rooms are austerely decorated. The corner towers conceal smaller rooms where the other parties and other boards can meet. Since the respect for the old facade did not permit to put new windows in the Reichstag building facade, the two large party rooms are toplit.

Above:
The lobby

Right: Access
to the tribunes

Old and new intersect noticeably at the light wells. The ground floor is the plinth of the Reichstag building faca-de, articulated by the original roundarch windows on the level of the old Chamber and the square ones which once marked the storey above it. The third level with the poli-tical parties' rooms and the press foyer are clearly demar-cated from the old shell of the building by floor to ceiling glass partitions.

Reserved for members of the Bundestag and officials, the main entrance to the building is on the east side.

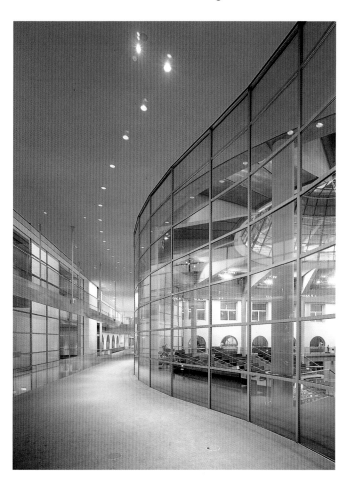

From it there are several direct approaches to the Chamber as well as the offices and the reception rooms occupied by the Bundesrat, the Bundestag President and the all-party parliamentary committee on the third floor.

The old west lobby running parallel to the facade is separated from both the entrance and the Chamber by floor to ceiling glass partitions. Roundarch windows and the height of the ceilings show its relationship to the Chamber of deputies in 1894. To suggest the historical link, Norman Foster has faced the walls and paved the floor with stone, thus creating an effect of monumentality. The lobby still leads to the parliamentary restaurant as it did in 1894 and feeds into a lobby south of the western entrance. Once sumptuously panelled, the rooms are today decorated austerely but elegantly in keeping with the times. Modern forms and colors represent a contemporary parliamentary democracy in action. The restaurant is not the only eatery in the building. A bistro and a cafeteria as well as a clubroom cater to the inner needs of parliamentarians.

The great height of the old lobby made it possible to add a mezzanine linking it on a higher level with the tribunes and the information rooms beyond, which are used for guided tours. Its elegantly curved glass balustrade echoes the ellipsoid seating arrangement inside the Chamber.

Wherever the old relief sculpture was still in place, it has been carefully restored to contrast with the modern décor and democratic spirit of the capital. Traces of history recur throughout the Reichstag building. War and reconstruc-

Corridor with
Russian graffiti

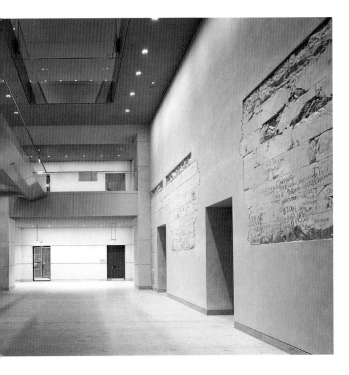

tion have banished most of the sandstone decoration and elaborate reliefs that made the building at once forbidding and familiar. However, some of the 19th century decoration has survived to contrast, like the grafitti scrawled by Red Army soldiers, with the freshly plastered walls. For the most part harmless like the legacy of tourists everywhere, the surviving Russian graffiti were not discovered until renovation work was going on. With the scars left by the Battle of Berlin in 1945, the graffiti represent legible history in the making, and as such have been integrated in the reconstruction of the Reichstag building.

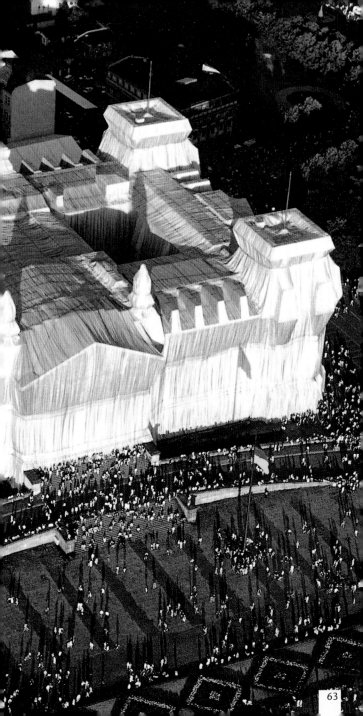

At the very last minute, the New York based artists Christo and Jeanne-Claude were allowed to go ahead with their spectacular plans for wrapping up the Reichstag building. Mooted since the 1970s, the project embroiled German politicians and the German public in heated debate. Just before construction work was due to start, Christo and his wife packaged the Reichstag in a

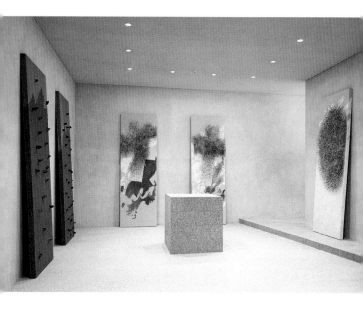

shimmering metallic fabric. The act signified a public farewell to the old building before it became the seat of the democratic parliament of a reunited Germany. Wrapping transformed the Reichstag building into a vast luminous object which changed hue with the passing of the hours. Over five million visitors came to marvel at this grandiose sight. The ambience around the "Wrapped Reichstag" was laid-back. During wrapping, while it was still in place and long afterwards, heated discussion continued worldwide on how a once ominous national political symbol could be thus transmuted overnight into an art work of such uplifting significance. The reconstruction work to follow could not have had a more auspicious inauguration.

Page 62/63: The wrapped Reichstag building, summer 1995

Above: Günther Uecker's non-denominational chapel, 1999

Right: "Friedrich's melancholy" by Georg Baselitz, 1998

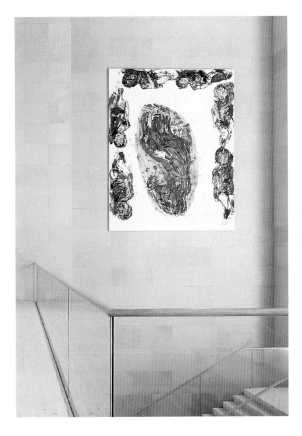

Among the art works purchased for the Reichstag building is a drawing in color by Christo and Jeanne-Claude (1986), now hung in the visitors' restaurant on the roof.

Günther Uecker has created a serene chapel on the south side of the building. A windowless room, it tranquilly enfolds those who seek it out, concentrating their thoughts in meditation. Seven wooden panels leaning against the wall, some spiked with nails, others pierced by stones or painted unspecifically evoke Judaic-Christian motifs. Furnished with an austere altar block and archaically suggestive wooden chairs with high backs, the Reichstag building chapel is non-denominational and therefore open to all.

Two large Georg Baselitz paintings, each five by four meters, have been hung in the south lobby. The motifs and the Baselitz variations on them stem from the work of the sublime Romantic painter Caspar David Friedrich. His "Melancholy" as well as other motifs from German Romantic painting are repeated within the works as framing elements and are reproduced upside down at the center. The sensuous quality of the handling is thus emphasized while figurative representation is played down.

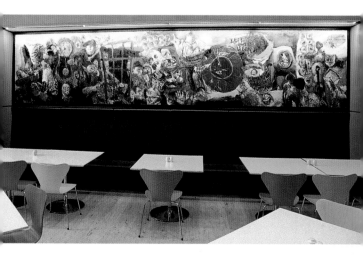

The chapel and Baselitz's paintings are not the only art works created specially for the revitalized Reichstag building. Nineteen artists were asked to submit designs for various rooms and were subsequently commissioned by the Bundestag Art Advisory Council to carry out their plans. Earlier works by seven other artists were purchased to complete the lasting transformation of the building.

Above:
"Time and Life"
by Bernhard
Heisig, 1998/99

Right: "To the
memory of ..."
by Katharina
Sieverding,
1992

Bernhard Heisig has done "Time and Life", a panorama of German history roughly six meters across for the Bundestag cafeteria. This elongated work might be classified as a modern version of the old genre of history painting. Recurrent motifs like Frederick the Great, a "swastika man" and a soldier characterized as "only doing his duty" constitute collectively a critical survey of German history.

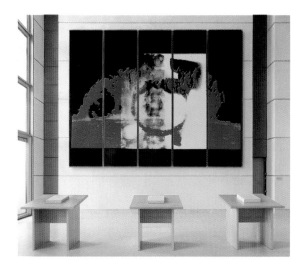

Quite a stir was created when the suggestion was first made to include "official artists of the GDR". Internationally known artists had to be commissioned to work on a project of such importance to a modern democratic Germany. A younger generation of German artists will be represented in other Bundestag buildings. A judicious balance has been struck between East and West. Consequently works of art by East Germans like Gerhard Altenbourg, Hermann Glöckner and Lutz Dammbeck have been purchased, as well.

Katharina Sieverding's 1992 installation in the lobby dedicated "To the memory of those Members of the Weimar Republic who were out-lawed, tortured and murdererd during the Regime of Terror, 1933–1945" deals with German history. Consisting of five complex, layered and digitally revised, solar and x-ray pictures of tumours and a separate table presenting the documented biographies of the parliamentarians, it draws together metaphorically two themes, National Socialism and degeneration.

The north lobby is thirty meters high. Here Sigmar Polke has installed five light boxes which look like advertising display cases. When you go by them, however, you realize that the pictures change with you as you move. Polke

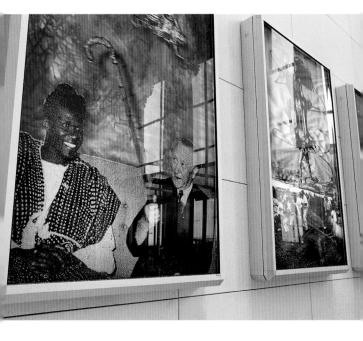

is interested in iridescence, the change making motifs go from recognizable to unrecognizable. He has mounted figures of Konrad Adenauer, the medieval scapegrace Till Eulenspiegel and a visiting African dignitary as well as numerous other figurative motifs in a kaleidoscopic collage.

The American artist Jenny Holzer has made a stele with political quotations in digital letters for the north lobby. Running in chronological order from top to bottom and covering all four sides of the stele, the quotations are from speeches and in the Reichstag from 1871 and the Bundestag up to 1998.

Across from Polke's boxes in the north lobby Gerhard Richter's three color panels are as high as the lobby itself. Recalling the German flag, they are about 3 by 21 meters and their glossy surfaces are irritating. Richter's drastically reductive handling of color, form and material represents his detached and cool commentary on painting itself while creating a subtle link with the place where the work is positioned–within the Reichstag building.

Above: Five light boxes by Sigmar Polke, 1999

Right: "Running oral history" by Jenny Holzer, 1999

Page 70: "Black, Red and Gold" by Gerhard Richter, 1999

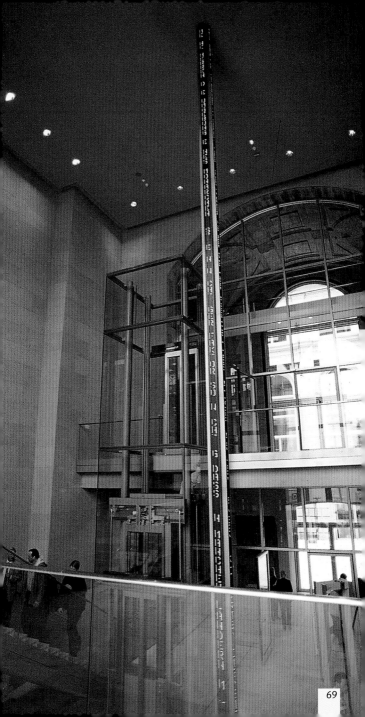

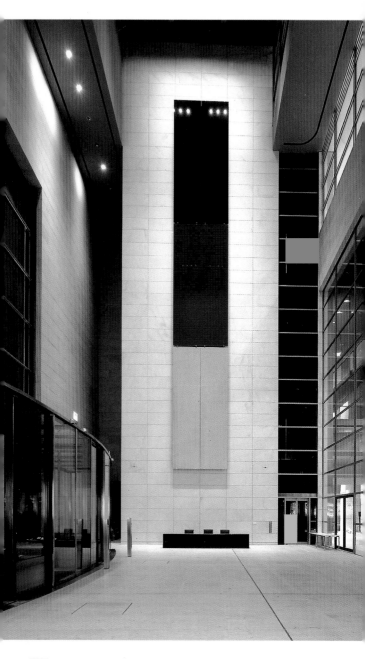

Further information on Norman Foster can be found on the
following website: http://www.fosterandpartners.com

Photo credits
Author's Archive: 14, 16, 17 · Bildarchiv architekturphoto, Düsseldorf: 42-43,
46, 54, 57, 58, 59, 65, 67 · Bildarchiv Preußischer Kulturbesitz, Berlin: 6 o., 7 o.,
7 u., 13, 15, 18, 19, 21 u., 24, 27 · Jan-Peter Böning/zenit, Berlin: 4, 35, 66, 68 ·
Bundesbaugesellschaft, Berlin: 32-33 (Antonia Weiße), 36-37, 38-39 · Photo
Collection W. Schäche, Berlin: 21 o. · Reinhard Görner/CONTUR, Cologne:
40-41, 70 · Werner Huthmacher/Architekton, Mainz: 8, 43 u., 44 , 45, 47, 53,
55, 56, 61, 64, 69 · Landesbildstelle, Berlin: 2-3, 6 u., 9, 10-11, 12, 20, 22 o.,
22 u., 23, 25, 26 o., 34 · Erik-Jan Ouwerkerk, Berlin: 26 u., 48-49, 49, 50-51,
51· Reimer Wulf, Elmshorn: 3, 28-29, 30-31, 62-63

On the front cover: The dome of the Reichstag building at night
(photo: Erik-Jan Ouwerkerk)

On the back cover: The Reichstag building with the new dome
(photo: Erik-Jan Ouwerkerk)

Title page: Bundestag President Wolfgang Thierse unveiling the new Federal
eagle on 17 December 1998 (photos: Erik-Jan Ouwerkerk)

Maps: Heike Boschmann, Computerkartographie Carrle, Munich

© Prestel Verlag, Munich · London · New York, 1999
Die Deutsche Bibliothek – CIP-Einheitsaufnahme
The **Reichstag Berlin** / Ralf Wollheim. - Munich ; London ; New York :
Prestel, 1999 (Prestel guide compact)
Dt.. Ausg. u.d.T.: Der Reichstag Berlin
ISBN 3-7913-2250-8 (German edition)
ISBN 3-7913-2260-5 (English edition)

Library of Congress information is available.

Prestel Verlag · Mandlstraße 26 · 80802 Munich
Telefon 089 381709-0 · Fax 089 381709-35

Translated by Joan Clough

Edited by Alexander Kluy

Designed by Maja Thorn

Lithography by LVD, Berlin
Printed by Peradruck, Gräfelfing
Binding by Attenberger, Munich

Printed on chlorine-free bleached paper
Printed in Germany

ISBN 3-7913-2250-8 (German edition)
ISBN 3-7913-2260-5 (English edition)

THE REICHSTAG

Norman Foster's
Parliament Building

With a foreword
by Norman Foster

Berlin is in the throes of a building boom on a grand
scale. The German capital is once again a vibrant metro-
polis at the heart of contemporary Europe. At the core
of all this pulsing activity is the revitalized Reichstag build-
ing, the work of the renowned English architect Norman
Foster. He has incorporated his ideas of democratic form
and function in this recreation of the old Reichstag build-
ing, crowned by a vast glass dome. Always accessible to
the public, it can be mounted via helical ramps and is an
ideal vantage point for viewing the city.

Norman Foster (*1935) is the founder of the architectural
practice Foster and Partners, a London based firm of
architects active worldwide. His work includes the head-
quarters of the Hongkong and Shanghai Bank, Hong
Kong, Stansted Airport near London, the Century Tower,
Tokyo, and the Commerzbank Headquarters in Frankfurt
am Main.

120 pages with approx. 80 illustrations in color and approx.
40 in black-and-white. 17 x 22 cm. Available from October 1999
ISBN 3-7193-2153-6 (German) DM 19.95
ISBN 3-7913-2184-6 (English) US$ 16.95 Can. $ 19.95 £ 9.95

Prestel
Munich · London · New York